Lewis and Clark: An Expedition From Pittsburgh

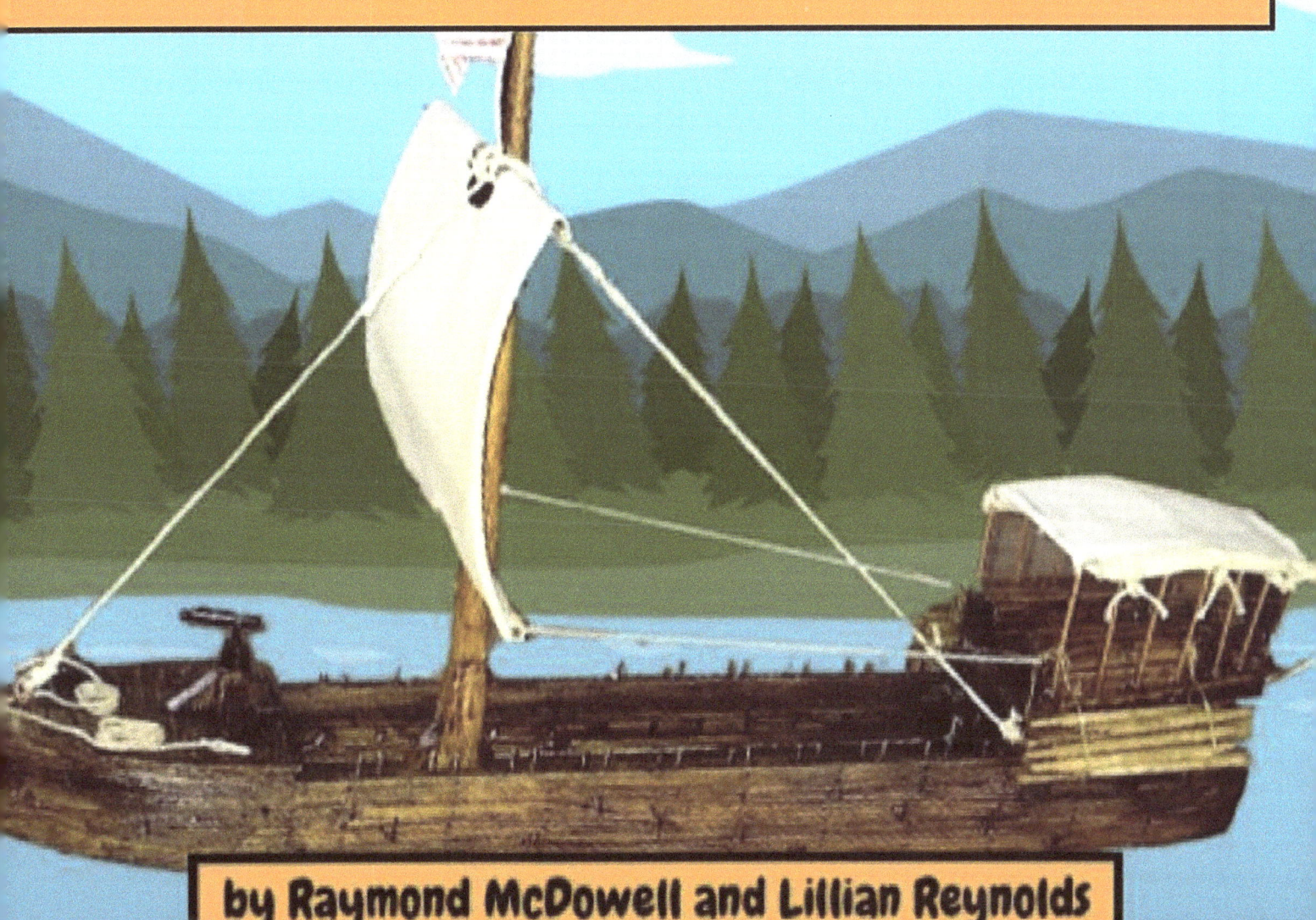

by Raymond McDowell and Lillian Reynolds
with Brenda Applegate

Dedicated to anyone with a love for nature and heart for adventure

Text by Raymond McDowell and Lillian Reynolds

with Jacob Gorczyca,

Some Images used with permission under creative commons license

Copyright © 2022 by Grow a Generation

All rights reserved. This book or any portion thereof may not be reproduced or used in any manner whatsoever without the express written permission of the publisher except for the use of brief quotations in a book review or scholarly journal.

ISBN 9-781-435-775-077

Grow a Generation
Sewickley, PA 15143
www.growageneration.com

Any and all profits from the sale of this book benefit the Beaver County Historical Research and Landmark Foundation

Hi! My name is Seaman and I am a Newfoundland dog.

My master is Meriwether Lewis. He is a very important person.

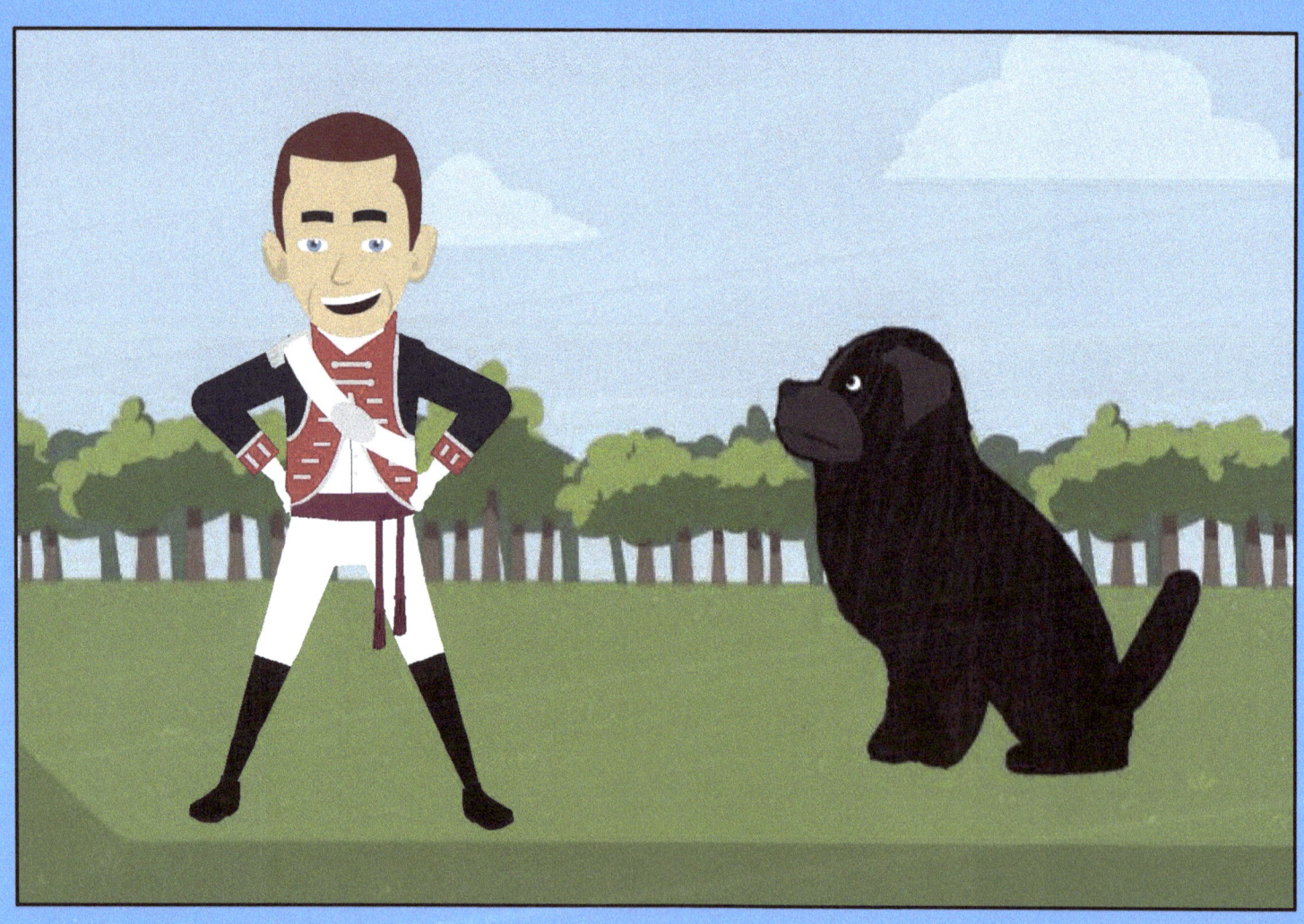

Maybe you have heard of him?

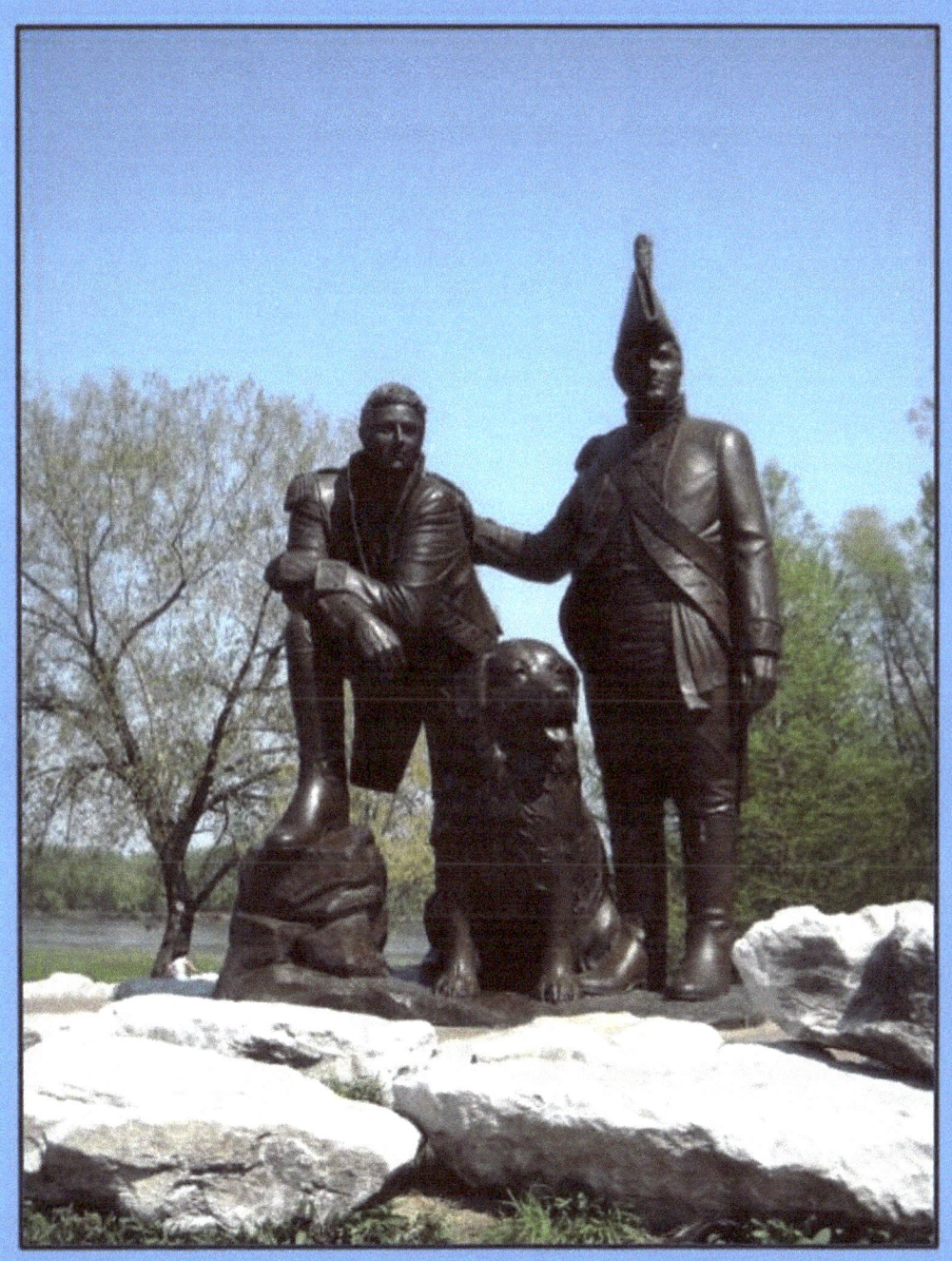

Lewis joined the army as a young man and rose to the rank of captain.

That's where he met his friend, William Clark.

Lewis was also friends with Thomas Jefferson who was the third President of the United States. Their families were neighbors back in Virginia.

As soon as he was elected, President Jefferson asked Lewis to be his personal secretary, and Lewis said yes.

In 1803, Thomas Jefferson made the Louisiana Purchase for $15 million which added 828,000 square miles of territory to the United States. It doubled the size of the country!

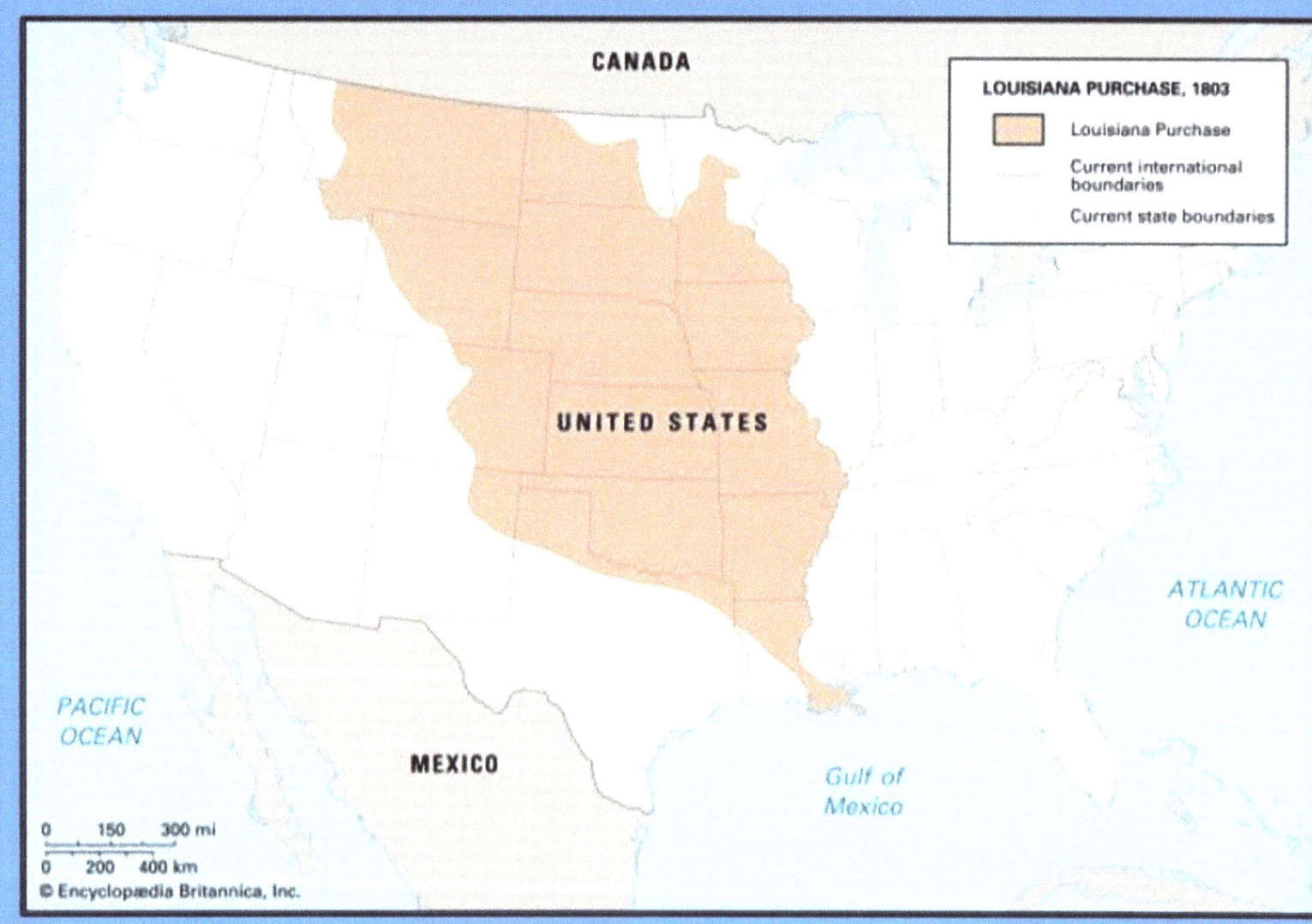

The President needed someone he trusted to explore the new land, so he asked Lewis!

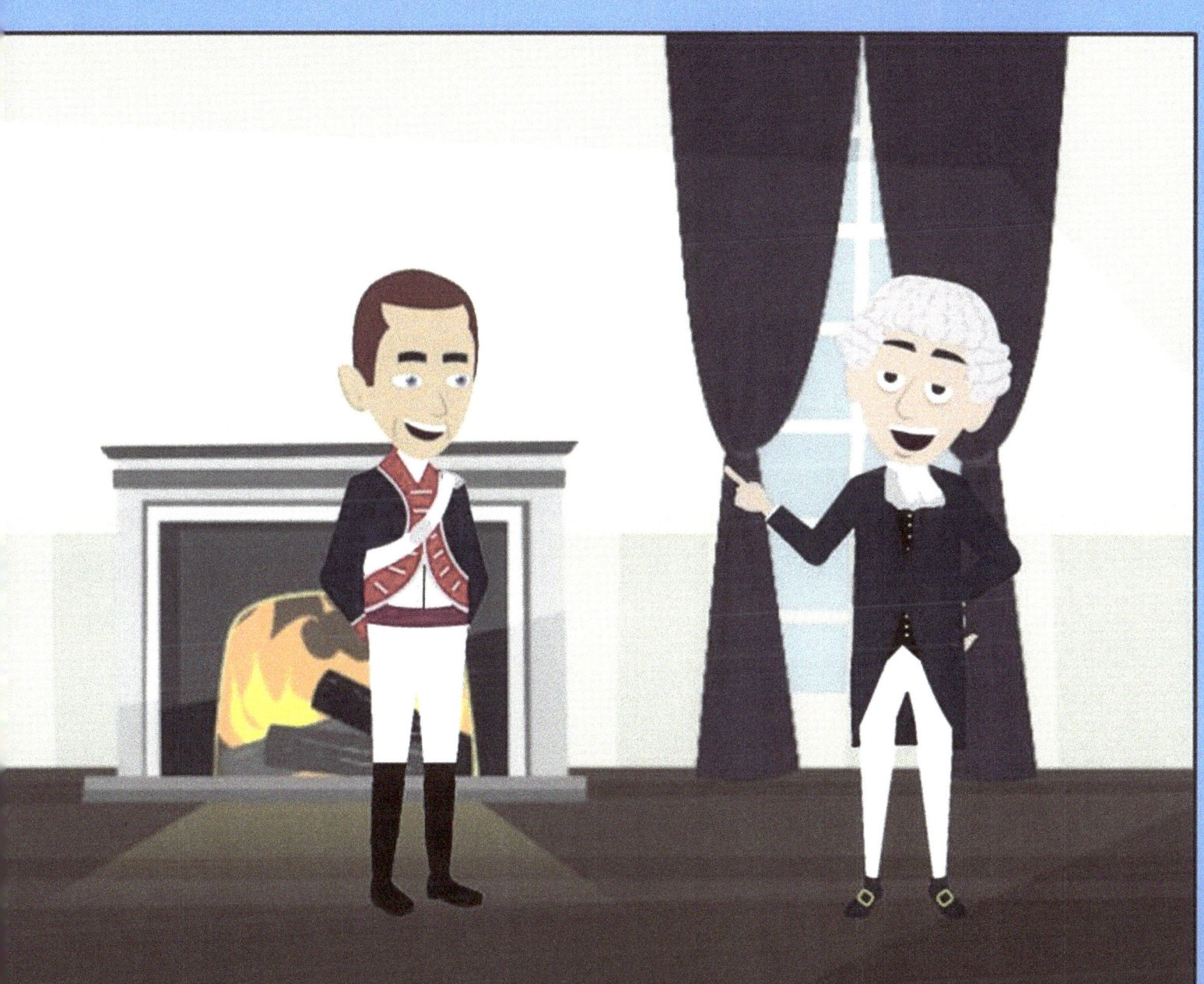

Lewis was taught how to identify and classify the plants and animals he would find. He was also taught how to make maps of the new land, as well as how to have friendly dealings with the natives.

He also had to learn about the design and sailing of boats.

To explore the new territory, he needed a special boat that could carry many men and a large quantity of supplies on the Ohio, Mississippi, and Missouri Rivers.

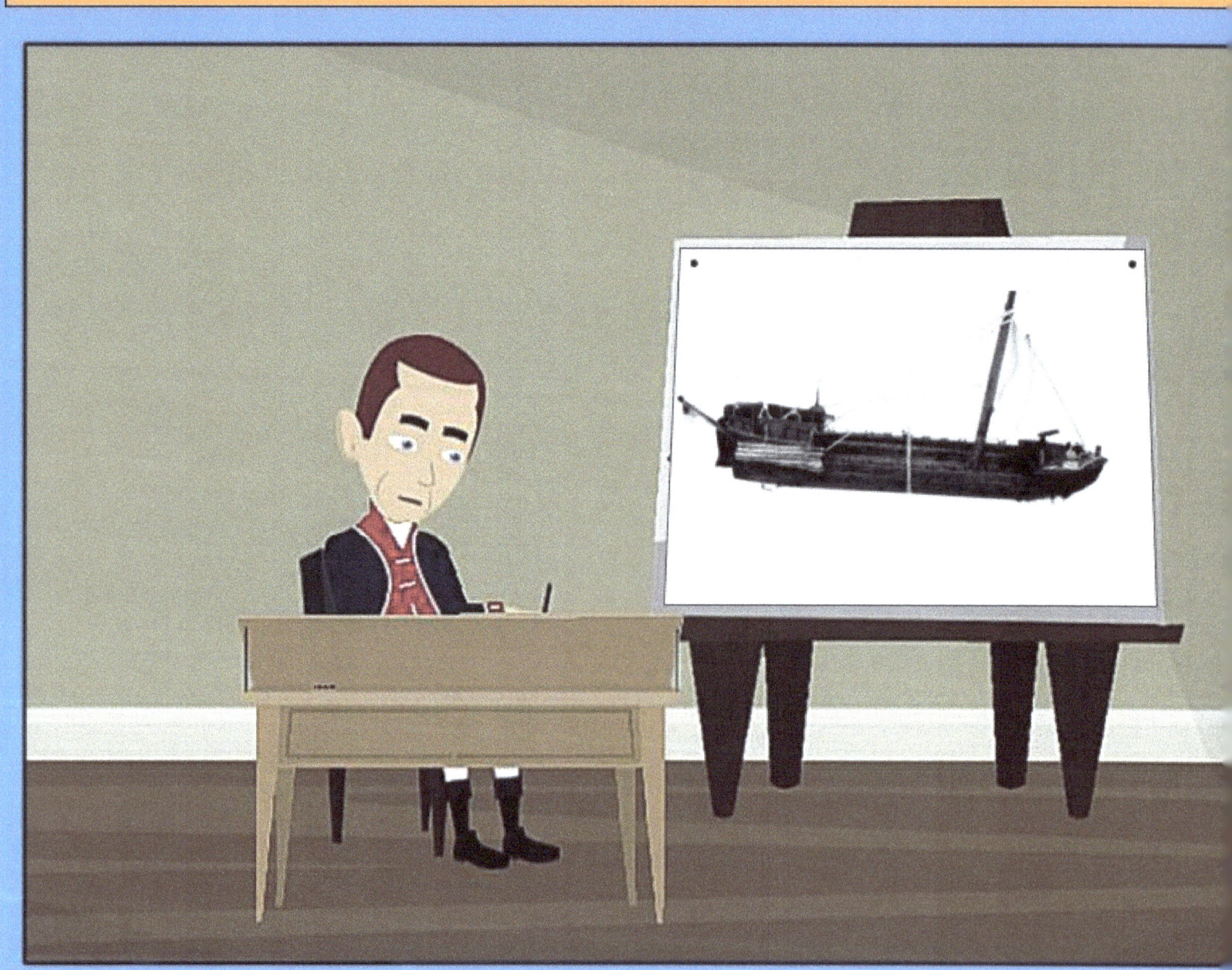

With the help of The President, Lewis worked with the boat builder to design a keelboat that had a sail as well as oars.

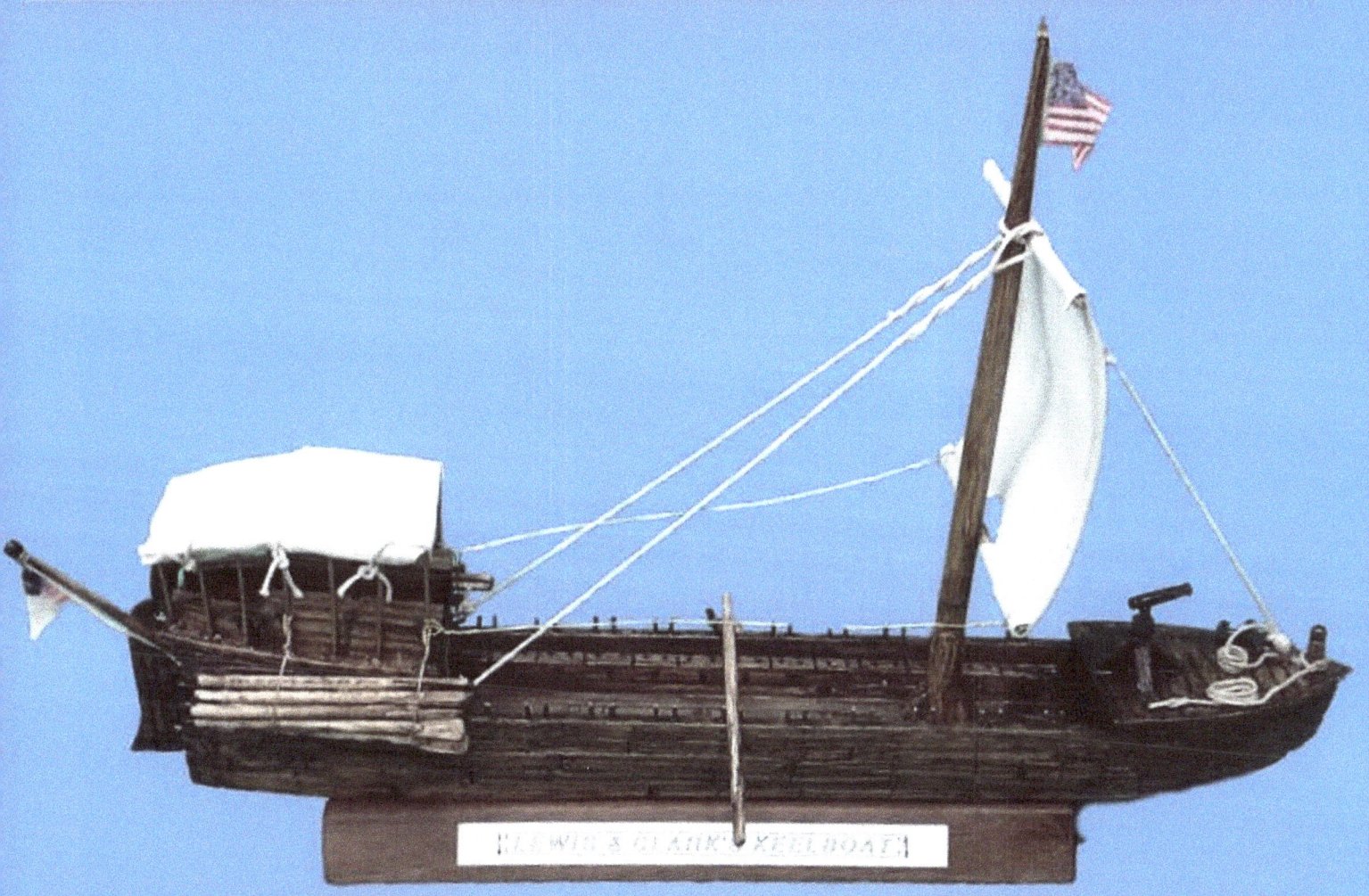

Sails would be used on windy days and the large long oars used to move the boat on calm days.

Lewis planned to leave from Pittsburgh early in the summer of 1803. He would sail down the Ohio River and up the Mississippi River to reach the frontier city of St. Louis, the gateway to the new territory.

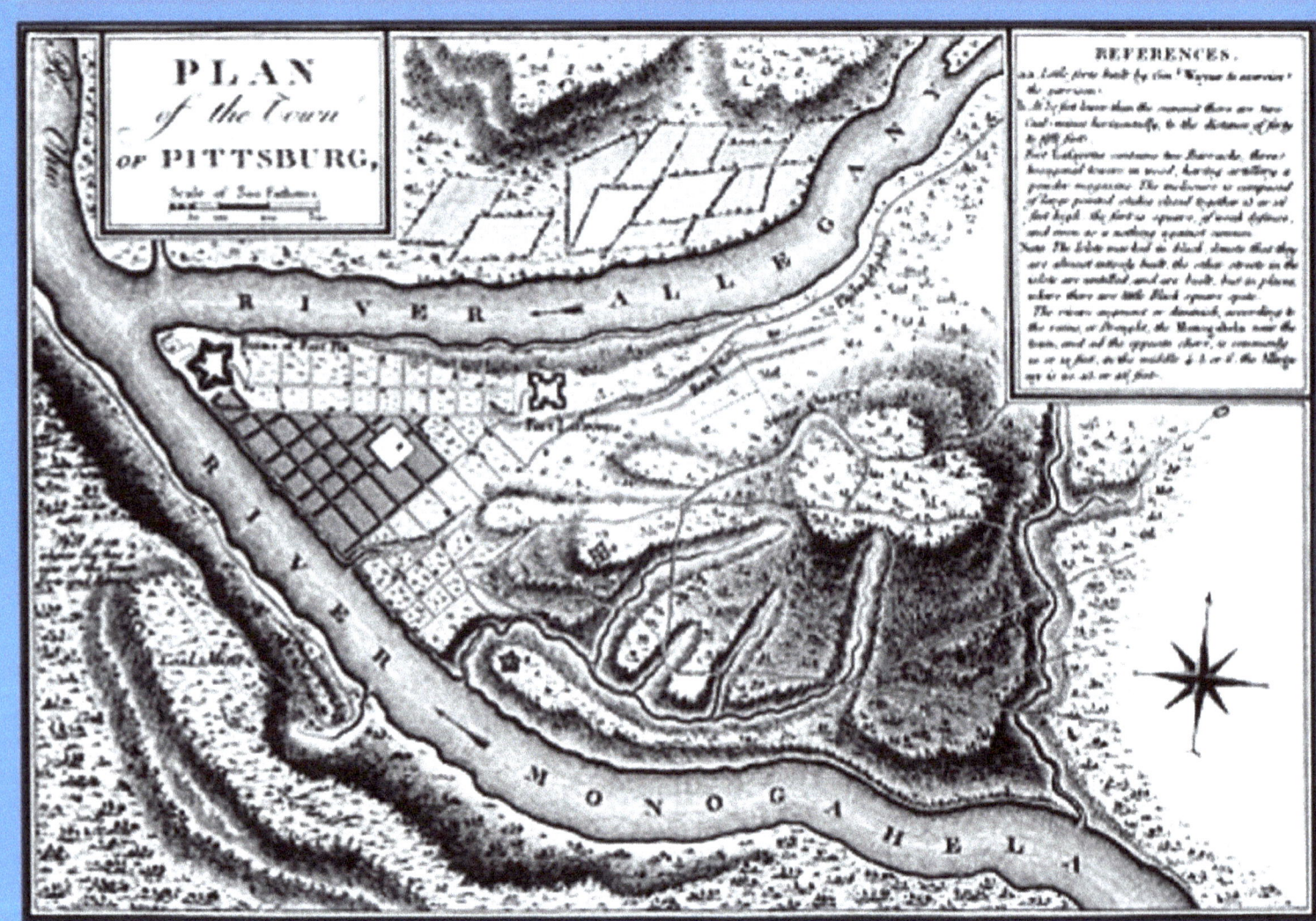

Lewis had supplies delivered to Pittsburgh and went there to supervise the building of the keelboat.

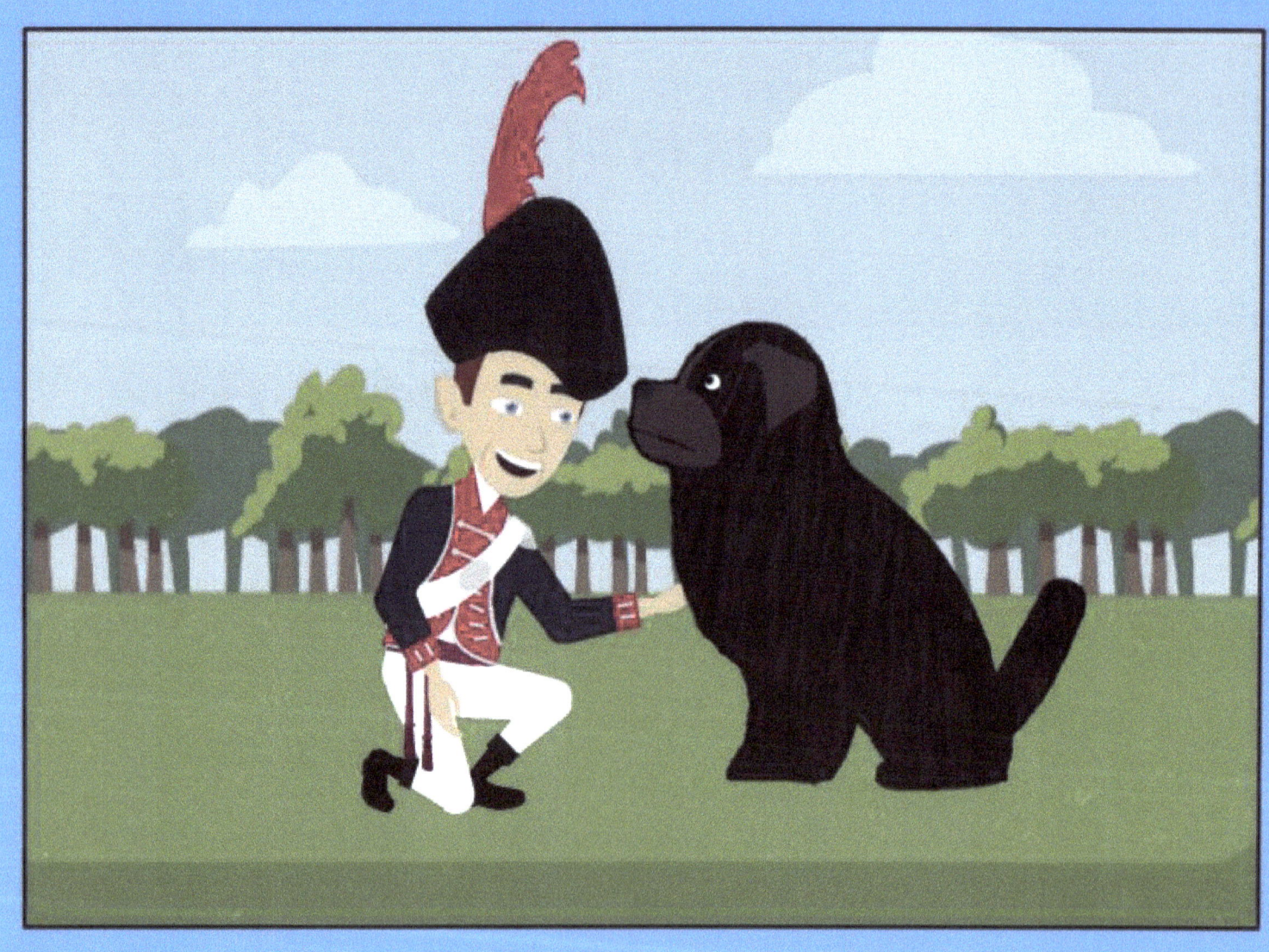

It was my job to help hunt and to keep everyone safe.

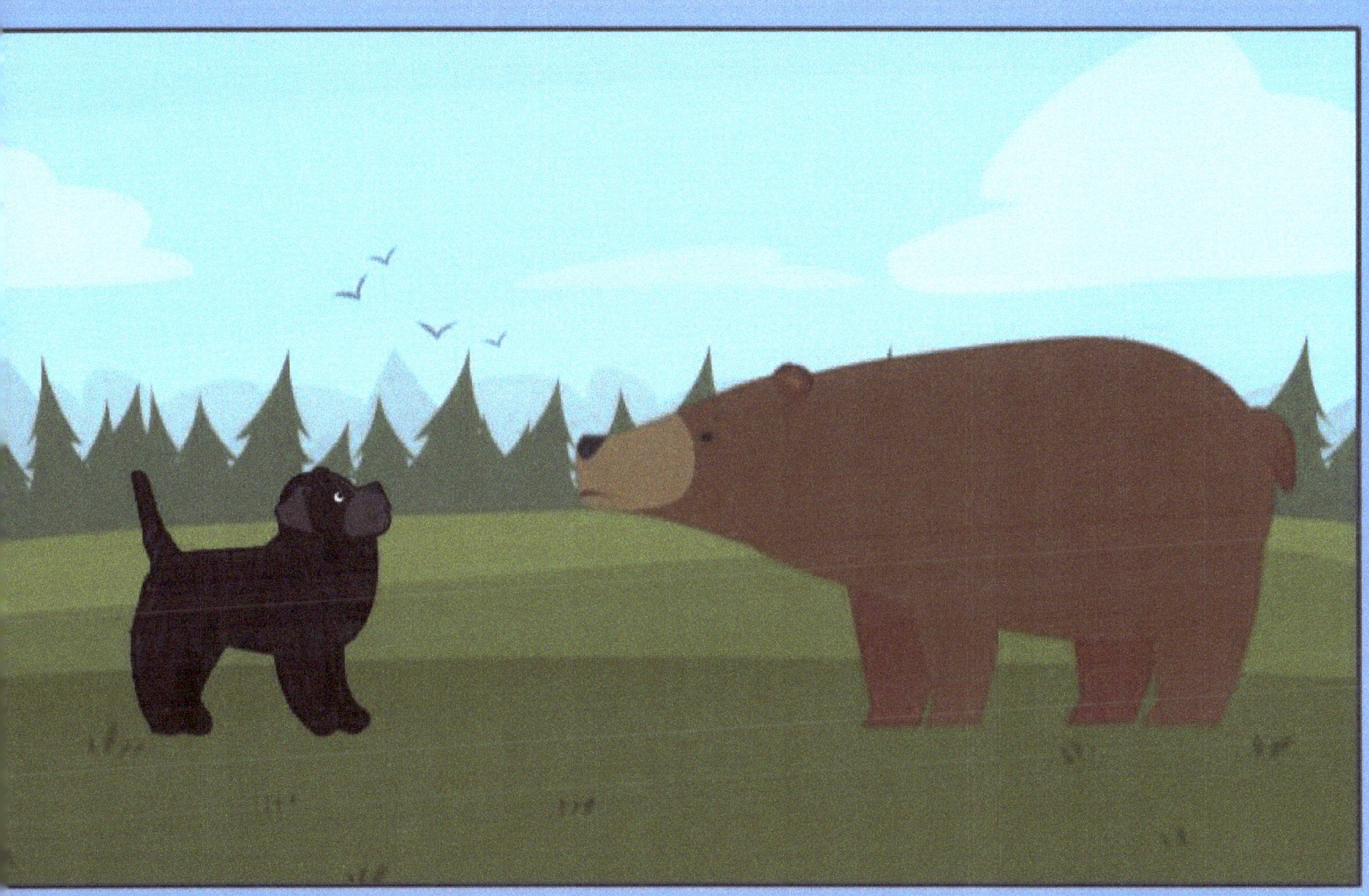

Even from big scary bears.

It took a long time for the boat builder to complete the boat. Master Lewis worried a lot about this and wrote about it in his journal.

The Ohio River becomes shallow during the hot summer months. Master Lewis knew that if we had to wait, the trip would be more difficult.

After over a month of waiting, we were finally ready to set sail. We left Pittsburgh with a crew of eleven.

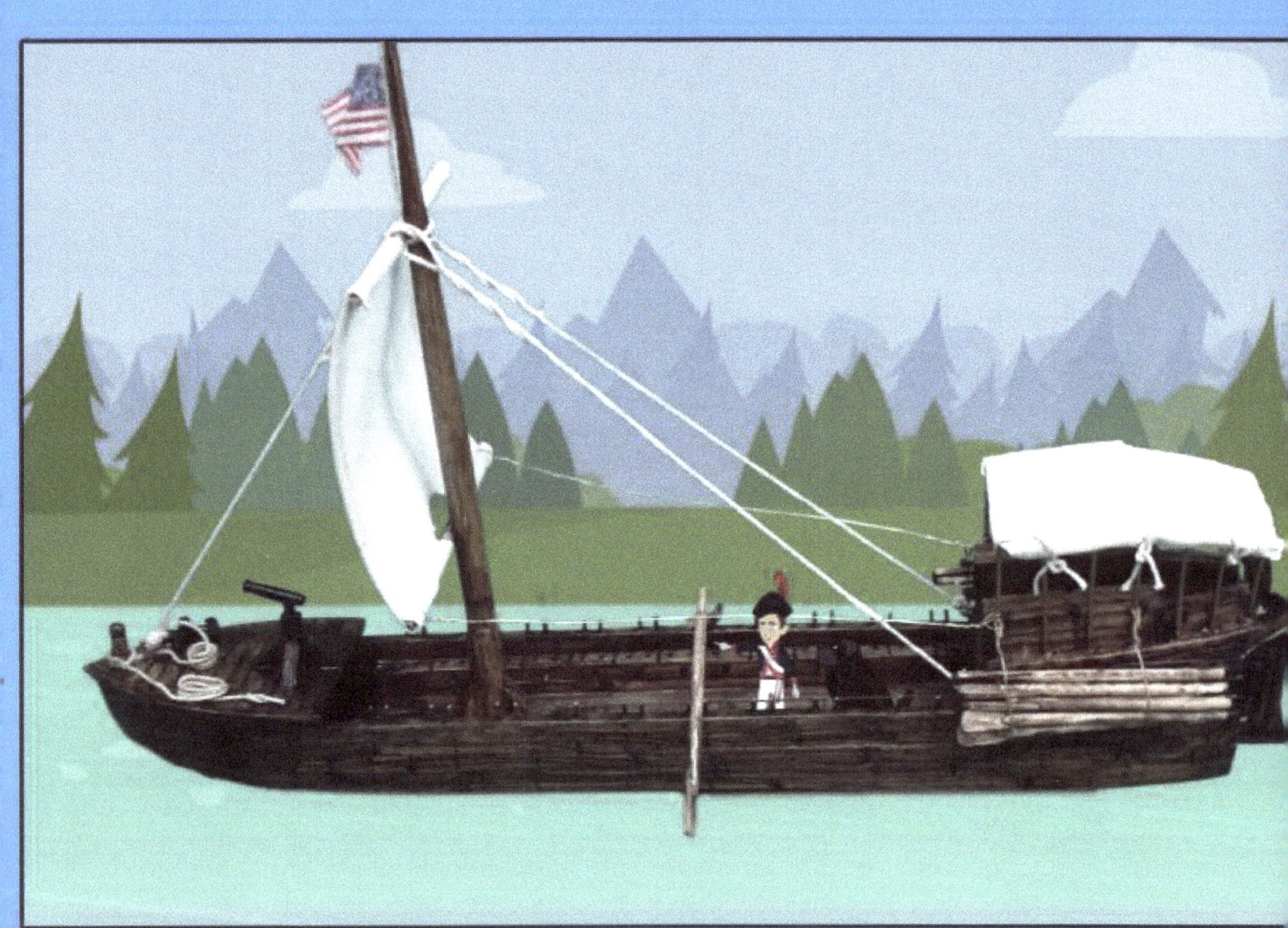

We picked up our friend, William Clark, at Clarksville, Indiana. Master Lewis was very happy to see him. We also signed up nine more men for the expedition. More people to play with me!

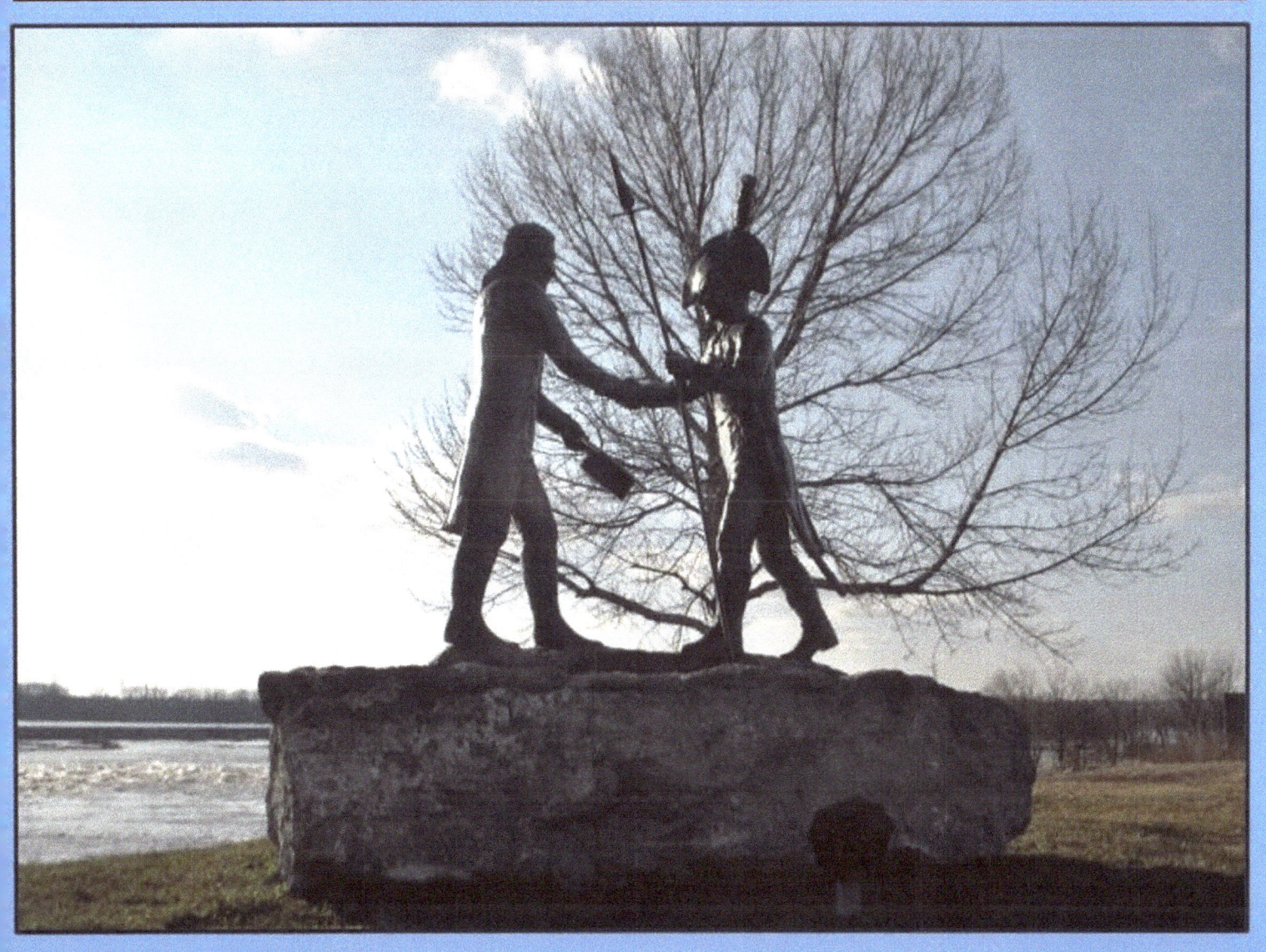

Low water levels made traveling down the Ohio River very difficult, and we got stuck on sandbars many times.

Going upstream on the Mississippi River was also very hard because we had to travel against the current. The journey was slow.

On December 12, 1803, we finally made it to our winter camp at Camp Dubois near St. Louis, Missouri.

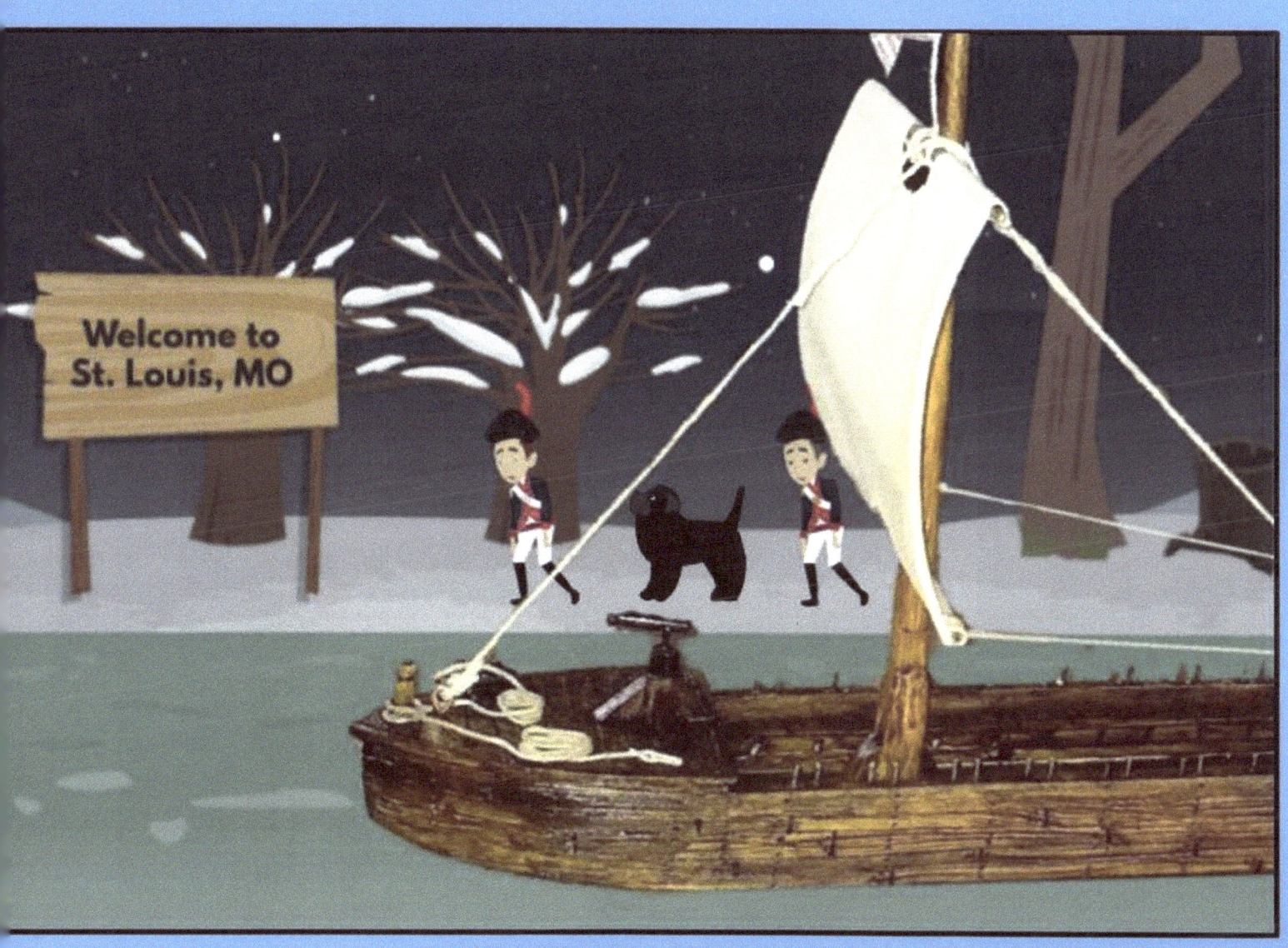

We stayed at Camp Dubois until Spring before we headed west to explore the new territory. Until then, we took time to obtain more supplies, as well as sign and train more men for the expedition.

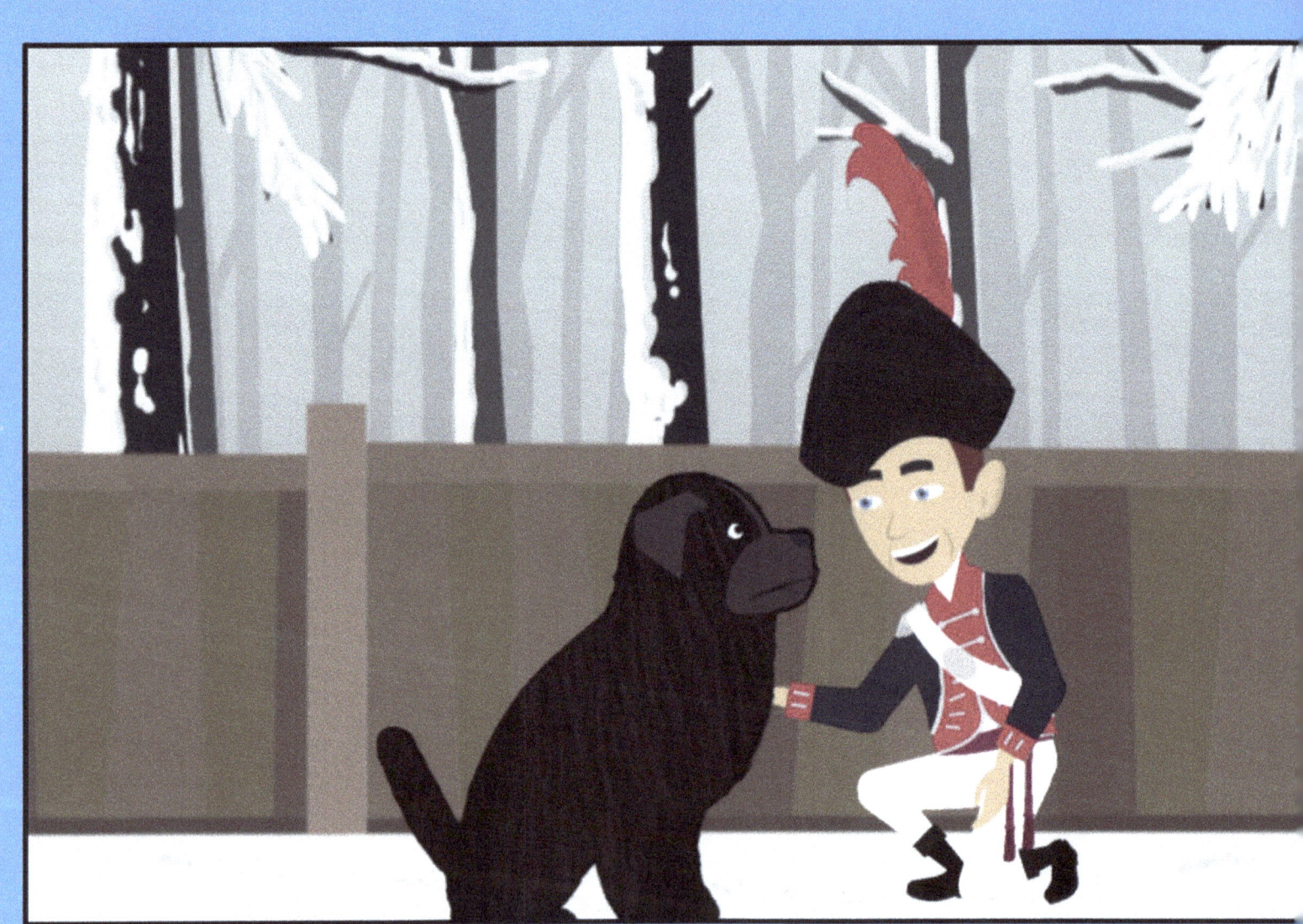

I, Seaman, enjoyed this long and exciting journey from Pittsburgh to the Pacific Ocean. We had a chance to see and explore a whole new world. We met many different Native American tribes and discovered hundreds of new animals and plants.

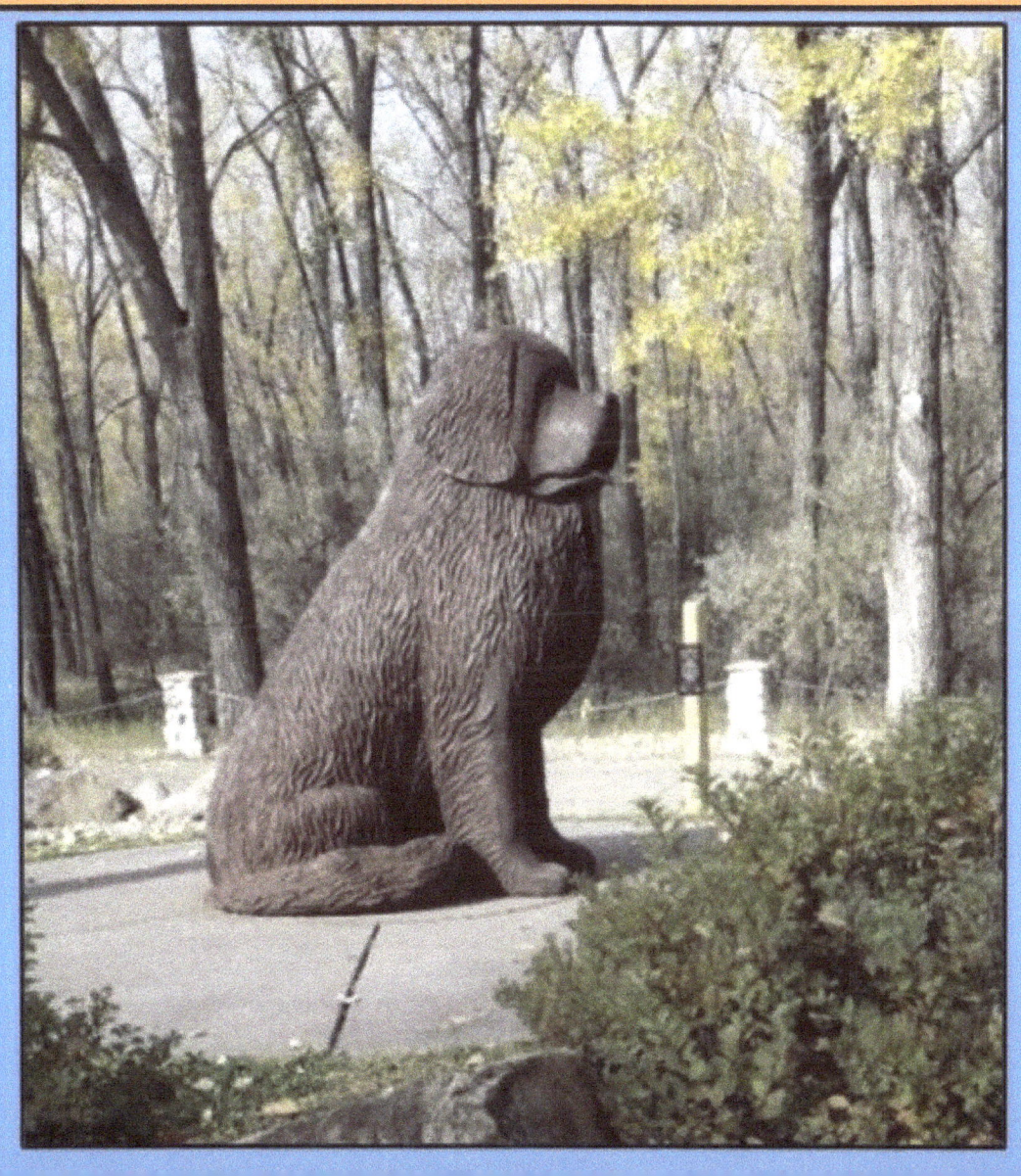

The authors participated in the dedication of the Sewickley trail marker. Signs like this highlight places where Lewis and other members of the expedition stopped on the Ohio River.

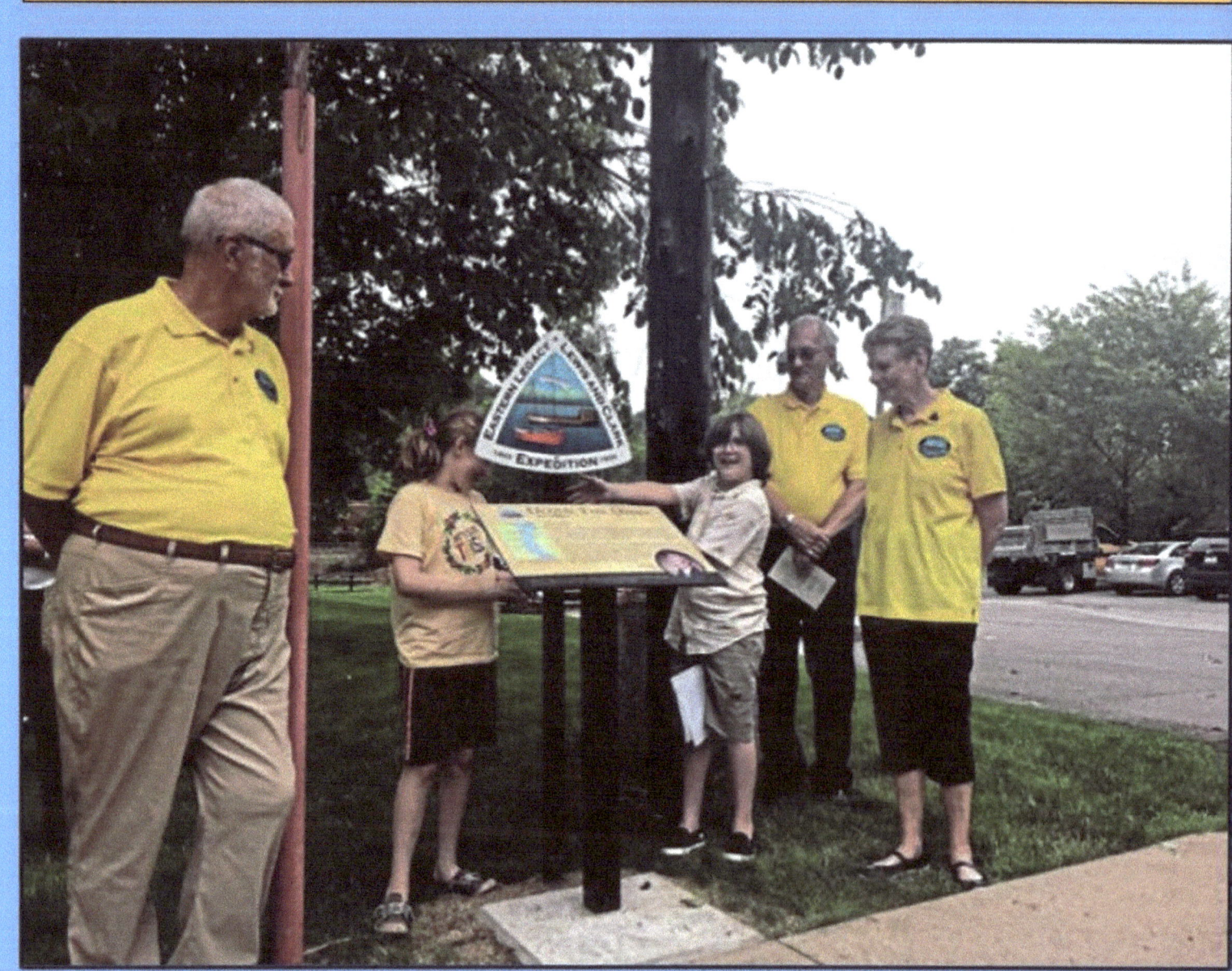

In 2019, Pittsburgh, Pennsylvania was added to the official Lewis and Clark trail along with the addition of a historic marker at the top of Mount Washington!

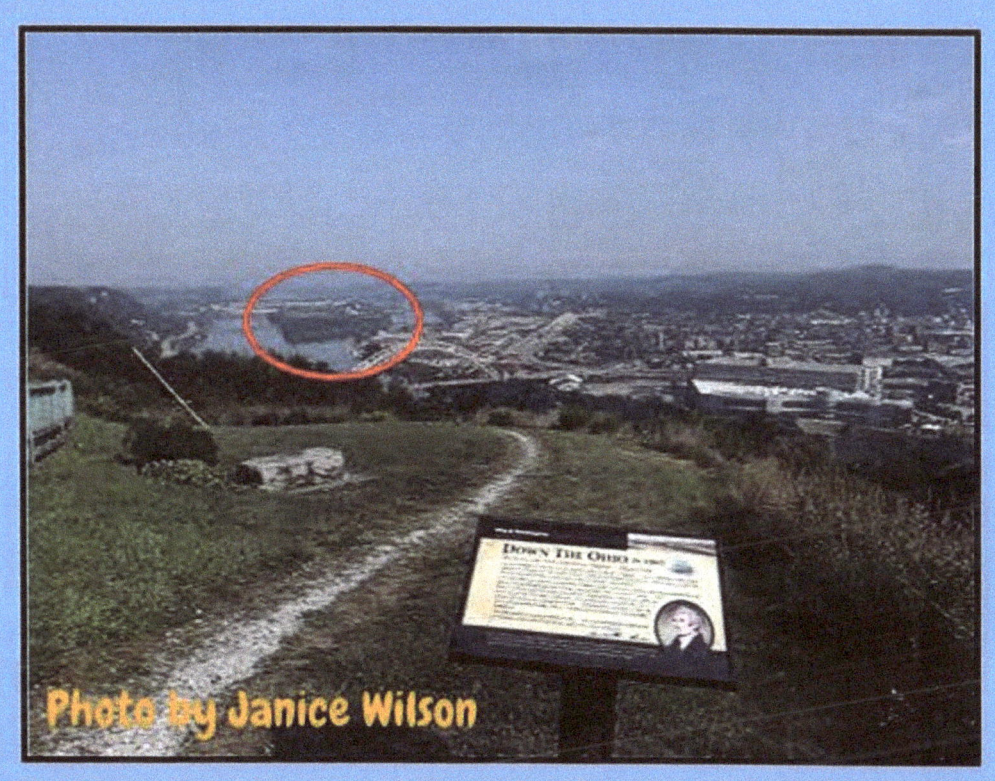

Photo by Janice Wilson

The marker overlooks the Ohio River, to commemorate the beginning of the journey. Just downriver is Brunot Island, mentioned in Lewis' journal as their first stop of the journey.

Beaver County Historical Research and Landmarks Foundation

Any profits from the sale of this book are directed to the Beaver County Historical Research and Landmarks Foundation. The Foundation exists to research, collect and archive local history and artifacts, recognize Beaver County landmarks and educate the local and national audience via instructional programs, reference materials, publications, referrals and special events.

Brenda Applegate
Director, BCHRLF
Beaver County Historical Research and Landmarks Foundation

Special thanks to our mentor Brenda Applegate. Her dedication to preserving local history and supporting community organizations is safeguarding history for current and future generations.

In Memoriam
Dr. Ellen Cavanaugh
1963 - 2021

Dr. Ellen Cavanaugh was the founder of the Baden Academy Charter School's Media Lab and Grow A Generation, LLC. She dedicated countless hours to teaching her students how to research, how to use technology, and how to write and create films. She encouraged them to question their findings and learn as much as possible, thus enabling them to reach their goals. Her encouragement and energy had a great impact on her students and their families. Our authors, Lillian and Raymond began this project under her guidance.

Thank you Dr. Ellen Cavanaugh

Baden Academy Charter School

This public charter school in Western PA works to inspire personal excellence. They cultivate the inherent gifts and talents present in all children by providing a curriculum that integrates the arts and sciences in a highly interactive, hands-on environment.

Grow a Generation

Grow a Generation partners with gifted and talented young people and teachers to make meaningful projects possible. Faculty, students, and student teams apply in their school to be accepted into the fellowship program. Once selected, they embark on a year-long odyssey to publish a book, create a digital artifact, or enter a STEM competition. Find out more at growageneration.com

www.ingramcontent.com/pod-product-compliance
Lightning Source LLC
Chambersburg PA
CBHW041922180526
45172CB00013B/1358